ARIZONA'S
RED ROCK COUNTRY

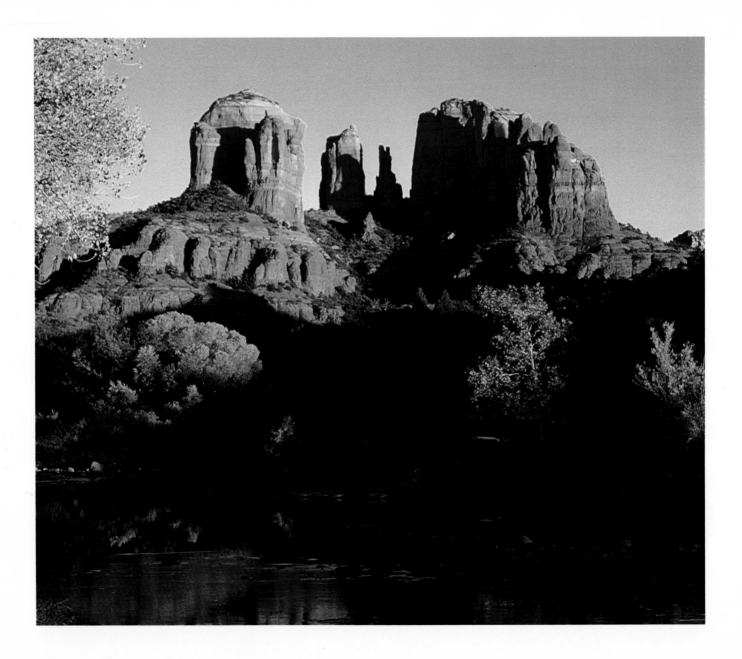

ARIZONA'S
RED ROCK COUNTRY

SEASONS in
OAK CREEK CANYON
and SEDONA

TEXT by LARRY RUSSELL
PHOTOGRAPHS by DICK CANBY

NORTHLAND PRESS FLAGSTAFF, ARIZONA

For further information on camping facilities, hiking trails, or other recreational activities in the Oak Creek Canyon-Sedona area, please contact the Sedona Chamber of Commerce or the United States Forest Service.

Copyright © 1984 by Larry Russell
All Rights Reserved
FIRST EDITION
Second Printing 1985
ISBN 0-87358-353-1 softcover
Library of Congress Catalog Card Number 83-63311
Composed and Printed in the United States of America

Library of Congress Cataloging in Publication Data
Russell, Larry A.
Arizona's Red Rock Country
1. Sedona (Ariz.)—Description. 2. Sedona Region (Ariz.)—
Description and travel. 3. Natural history—Arizona — Sedona.
4. Natural history—Arizona—Sedona Region. I. Canby, Dick.
II. Title.

F819.S42R87 1984 979.1'33 83-63311
ISBN 0-87358-353-1 (pbk.)

AUTHOR'S NOTE

The Oak Creek Canyon-Sedona area of Arizona has been my home, off and on, for the past fifty-six years, beginning in 1928, when my family first moved there. We lived at that time in a log cabin on the grounds of what was then called Mayhew's Lodge, at the head of Oak Creek Canyon. My first memory dates back to about 1930, when I was four; my mother, Nellie Pearl Russell, and I were wading across Oak Creek. I was holding onto the handle of a small red wagon, floating it behind me in the cold creek water. This early memory is almost entirely sensual: The great dome of blue sky above—the rippling murmur of creek waters—the beneficent sun—the incredibly fresh scent of soil and pine trees after a mid-afternoon thunder shower—the towering red cathedral rock formations at the junction of Oak Creek and West Fork —all blended and combined in a dizzying rush of impressions. I saw, in the words of Thomas Wolfe "the union of forever and of now." It was an altogether inspiring experience.

It was also a *fun* experience to grow up in the wilderness of Oak Creek Canyon and Sedona in those early, languid years. My boyhood friends and I developed a deep appreciation for the beauty surrounding us, and a healthy respect for the scorpions,

AUTHOR'S NOTE

rattlesnakes, and tarantulas that lived in the hills and arroyos. We had an abiding love for the wild burros that roamed free and became our reluctant but ever-amusing friends and playmates. We fished and swam and ran barefoot through the hills, playing endless games. When our family moved into Sedona itself in 1932, the only public buildings were L.E. "Dad" Hart's general store, the school house where I attended ten grades, and the ranger station that housed offices of the U.S. Forest Service. The area was totally isolated then, in the 1930s. Most of the families who gathered for the many community social activities were homesteaders who had moved in, cleared some land, and eventually "filed intention."

Jim Thompson was one of the first Sedona settlers, arriving in the 1870s. Jim made a squatter's claim to what is now called Indian Gardens. Reportedly, he moved in, nurtured the corn and squash crops left behind by renegade Apaches when they were rounded up by the Army, built a log cabin, settled in, and stayed on. Another pioneer arrived in the Sedona area in 1879, following a shootout in northern California. Jessie "Bear" Howard was said to have shot and killed a sheepherder during a range war; after being jailed briefly in Sacramento, he fled to Arizona, where he hid until those who were pursuing him gave up. Changing his name to Charley Smith Howard, he stayed in the Sedona area until he died.

Still another pioneer gave the town its name. T. C. Schnebly, who arrived with his family in about 1901, applied in 1902 for a post office permit from the government. He intended to call the postal location "Schnebly Station," but the government declined that name as being too long for a cancellation stamp. The alternative was "Sedona," his wife's first name, suggested by his brother,

AUTHOR'S NOTE

Ellsworth. It was accepted, and the town and the post office were thus designated.

Like so many others before him, my father, O. B. Russell, was captivated by the Oak Creek Canyon-Sedona area at first sight. Originally, I understand, our family was on its way to California from Texas, intending to meet relatives. My father and his brother, Lee, drove an old Model-T touring car, which broke down so often that they were finally required to stop in Flagstaff, Arizona, about thirty miles north of Sedona, and find work. They had to earn enough money to repair the automobile and continue on their way. My father found a job as a "powder monkey" (dynamiter) on a road gang that was involved in construction of the highway through Oak Creek Canyon. He immediately developed what locals called "Red Rock Fever," and decided to stay on in the area. In 1928, he moved us all to Mayhew's Lodge, at the junction of West Fork and Oak Creek. In its heyday, the lodge was one of the most famous and beautiful spots in the area; "Bear" Howard started the development in about 1880 with a log cabin, and others added to the buildings and grounds, until it grew into a gathering place for the famous and near-famous: presidents, movie stars, and author Zane Grey, who immortalized Oak Creek Canyon in his novels.

Through the years, as my brothers and I were growing up, we had a variety of jobs to help keep the family going, particularly during the Depression years of the thirties. Burrel, Earl, and Dick had odd jobs on ranches and nearby homesteads; they also share-cropped fruit and peddled watermelons, sweet corn, and freshly killed chickens from the back of trucks, traveling to the railroad

and lumbering town of Flagstaff in the north, and the mining towns of Clarkdale and Jerome in the south. My father and three brothers also earned money by "riding extra" in several movies, including Zane Grey's *Riders of the Purple Sage,* the first of dozens of films that have been made against the scenic background of red rock country.

Like many families in those early years, we kept animals for their products (milk and eggs) as well as their meat. There was no electricity—we read by kerosene lamps and Coleman gas lanterns. Our refrigerator was a gunnysack-wrapped box in the window with a container of water on top. Tiny holes punched in the container allowed water to flow at a very conservative rate through the sacks, and the breeze blowing through the wet burlap kept our food relatively safe from spoilage. Drinking water was hauled in one-hundred gallon steel drums by horse and wagon. Rain water, trapped and stored in a cistern, was used for cooking, doing the laundry, and taking Saturday-night baths. Times were often tough, but we survived, and had fun doing it. In retrospect, I doubt that any of us thought of ourselves as poor. After all, we were surrounded by nature's beauty and abundance.

There is much that has changed about my old home town. For one thing, there is a scarcity of the wild game that was so abundant during my childhood. Too, there are many, many more visitors to the area now, and a wealth of goods and services exist to accommodate them. The beauty of the area, however, is a constant. For the most part, it has not changed, has not been significantly altered by "progress" and "civilization." Red Rock Fever is still rampant!

There is no place quite like Sedona, although it can be likened

AUTHOR'S NOTE

to other southwestern attractions. It is set in a kind of miniature Grand Canyon, complete with ponderosa pines and a trout stream. Oak Creek Canyon's towering rock formations echo those found in neighboring Canyon de Chelly, Monument Valley, and Bryce Canyon. It is also the centerpiece of the geologic layer cake of red sandstone, yellow limestone, and black lava that is northern Arizona.

It is all of this and more. It is fire and ice — the lazy desert heat of summer and the brilliant, brittle cold of winter. It is new life, and death — the sweet, swift budding of spring, the flaming leaves of autumn. Oak Creek Canyon and Sedona offer four of the most glorious seasons to be found anywhere. Each has its own distinctive mantle, giving the scenic views a special drama as they rotate throughout the year.

Zane Grey referred to this special charm in *The Call of the Canyon.* Its clarion call is answered by more than two million visitors each year. Some arrive for the first time; others make it their habitual vacation spot or weekend retreat. Whatever the appeal for you, we hope that you find something of that spirit reflected in the words and pictures within this book, something you can carry home for fond remembering and sharing with those who have not yet experienced the seasons in Oak Creek Canyon and Sedona in person. There is truly no place like it in the entire world.

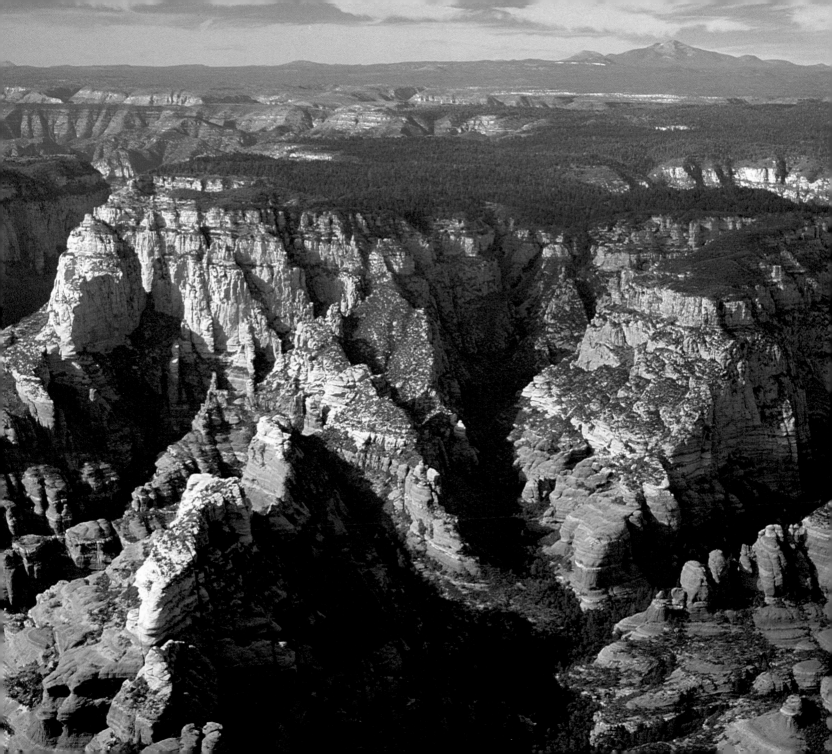

INTRODUCTION

*T*he impression made by Oak Creek Canyon on first sighting is memorable and breathtaking, no matter what the season. The impact never lessens, even with repeated visits. Flying across the canyon, or driving into it from Flagstaff or Phoenix, is an unforgettable experience.

Grey mountains surround a gash in the earth's surface at an edge of Arizona's desert landscape. These mountains are streaked with bands and escarpments of red sandstone (the color that gives the region its name) and yellow limestone, and capped with black lava strata. As one comes closer, the lush greens of ponderosa pines, the flamboyant reds of towering rock formations, and the bluish volcanic boulders scattered along the bed of Oak Creek reinforce the impression of an earthly rainbow. This impression is dramatized by fleecy white clouds spreading out overhead across the brilliant blue of Arizona's clear skies, and a searing but benevolent sun that bathes the deeply slashed gorges surrounding the town of Sedona in a golden glow.

Other first sightings are equally impressive. From the hills of Jerome or the summit of Mingus Mountain, there is a dramatic and breathtaking drop in the terrain. This Grand Canyon in miniature

An earthly rainbow

INTRODUCTION

suddenly spreads out below, beckoning all who see it to explore its beauty.

Those who actually saw it first, wandering into this Eden from the stark, desolate desert of southern Arizona, were probably an unnamed nomadic tribe of hunters. Archeological remnants suggest that they first appeared in the Oak Creek Canyon-Sedona area about 4,000 years ago. The most productive of the archeological excavations was made in the Dry Creek area west of Sedona. Charred bones and bits and pieces of ancient pottery and stone tools reveal a people who took their living from the land. Their meat diet of deer, bear, antelope, rabbit, porcupine, and other wild game was supplemented by the fruits of cactus plants, piñon nuts, agave, acorns, grasses, and roots. Caves gave them temporary shelter.

The Hohokam Indians are believed to have been the first to actually settle in the area, circa 700 A.D. "Hohokam" is a Pima Indian phrase that, freely translated, means "those who have vanished." Archeologists have traced their path northward along the natural waterways of the Verde and Agua Fria rivers. Traces have been discovered—and painstakingly reconstructed—indicating that the Hohokam lived in tiny, one-room huts, clustered together in groups, probably as a kind of defense measure as well as a social arrangement. The huts were primitive, fashioned from poles made of trees and brush in the area. Many of these dwellings were partially underground.

Like the Anglos who were to follow them centuries later, these early farmers dug extensive irrigation ditches and planted crops of maize, beans, and squash. They left stone arrowheads and pieces

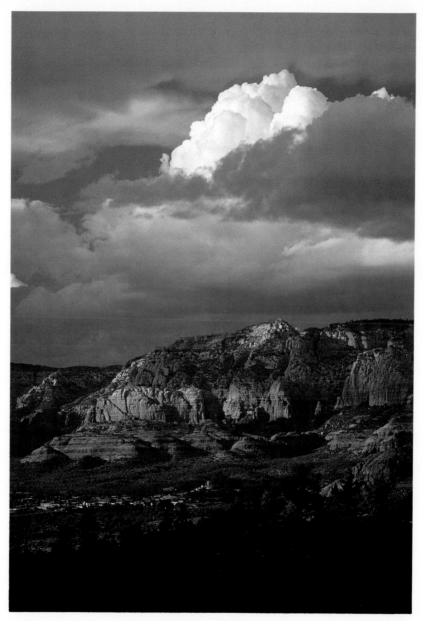

Sedona, nestled at the base of the red rocks

INTRODUCTION

of brown pottery decorated with red designs in their rubbish heaps, evidence to later investigators of their life and culture. They were followed by tribes of Sinagua, Yavapai, and Tonto Apache, and still later, by the Navajo and the Hopi. (The Tuzigoot ruins near Cottonwood and the Montezuma cliff dwellings south of Sedona, near Camp Verde, are two of the most popular sites, now preserved by the National Park Service, for learning more about some of these tribes.) There is something very mystic and un-spoiled about the Oak Creek Canyon-Sedona area, despite the centuries of human habitation. It is still possible to listen closely to the winds that play among cliffs, and to hear the moccasined footsteps and hushed voices of those people who preceded us.

The routes that lead us into the area today, however, are much less precipitous. Each is breathtaking, spectacular in its own right. Traveling into Oak Creek Canyon-Sedona from Flagstaff in the north, the road cuts through several miles of pine forest. U.S. Highway 89A South is a peaceful, meandering route; in the forest that borders it can often be seen grazing cattle, an occasional deer, grey squirrels dashing up rough-barked tree trunks, and even a wild turkey or two.

Suddenly, without warning, a spectacular sight comes into view on the northernmost rim of Oak Creek Canyon. A turnoff to the east leads to Observation Point at the top of the switchbacks, and the sheer drop into the gorge below spreads out, a magnificent vista. Here at its upper end near the switchbacks, the chasm of Oak Creek Canyon is approximately 1,500 feet deep; the lower end of the canyon, near Sedona, approaches a depth of 2,500 feet. Its sweeping width averages one mile from rim to rim. This

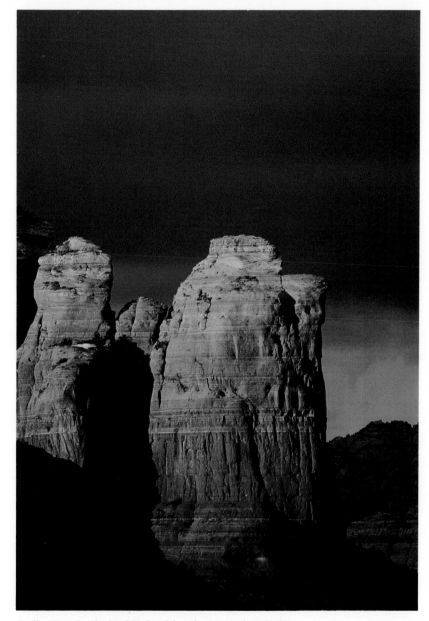

Coffee Pot Rock, highlighted by the sun's last light

INTRODUCTION

twelve-mile-long canyon cuts along the southern escarpment of the Colorado Plateau, and is flanked on the north and east by the sprawling Mogollon Rim, on the western edge by Sycamore Canyon Wilderness Area, and on the south by the pastoral farmlands of Verde Valley.

The switchbacks of 89A make a tortuous, two-mile descent into the canyon, cutting into the mountain in swirling loops and curves of asphalt that gradually snake down from the rim to the headwaters of Oak Creek near Pumphouse Wash on the canyon floor.

There are many well-equipped and maintained campgrounds nestled among the stands of ponderosa pine, Douglas fir, and oak; the U.S. Forest Service takes its responsibility very seriously here, stringently enforcing the space limits, a full-time job during the premium summer camping season. Underground springs, flowing through fractured sandstone rock, feed Oak Creek and its campsites, as well as two of the state's fish hatcheries.

The drive to the small community of Sedona is a restful and beautiful one. The road follows the banks of Oak Creek, and the sheer walls of the canyon loom first on one side of the road, then the other. The scent of pine is invigorating, especially after a mid-afternoon summer thunderstorm. This route carries one past Slide Rock, perhaps the most well-known and most frequently visited spot in Oak Creek Canyon. Here, where the water has worn a zig-zag groove in the sandstone creek bottom, thousands of people each season gather to "shoot the rapids," swept along in the cold rush of water through the groove and into a pool below.

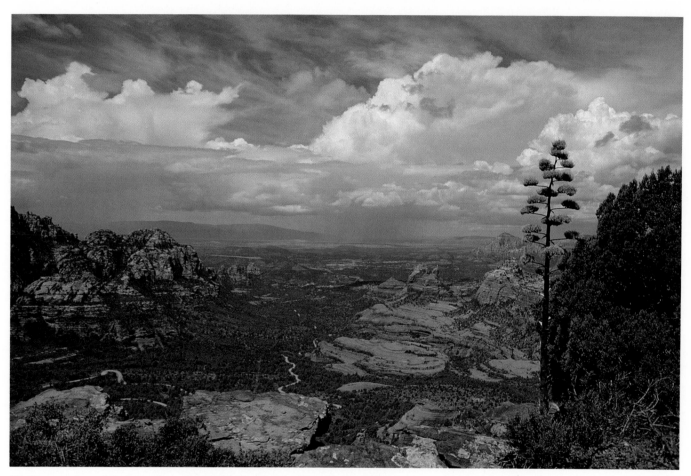

Bird's-eye view of Sedona, from the CCC Trail near Schnebly Hill Road

INTRODUCTION

The highway wends past Munds Canyon, Indian Gardens, Midgley Bridge, Steamboat Rock, and into Sedona, where it connects with Highway 179, the access route from Interstate 17 (Black Canyon freeway).

Ascending northward from the desert surrounding the highly urbanized community of Phoenix, Interstate 17 takes a long and lazy route through Copper Canyon and onto the ridge of the Verde Valley, where the ancient Hohokam are theorized to have entered the area. The route provides the traveler with a sixty-mile vista of stark chalk whites, lime greens, burnt oranges, and a palette of red that ranges from shades of soft rouge to dark rose. There is a definite pattern in this colorful array. The layers are symmetrical, composed of horizontal beds of a variety of sedimentary rocks. Further northward on this ridge, massive stone formations of colossal red rocks begin to appear.

Another less-traveled but no less scenic approach to the Oak Creek Canyon-Sedona area is Highway 89A, which goes through Prescott, Jerome, Clarkdale, and Cottonwood and into West Sedona. For many years, prior to the construction of Interstate 17, this was the only access to Sedona from Phoenix. It dates back to the founding of the mining town of Jerome and the very first narrow-gauge railroad (1886). At the time, those precarious rails served as the main route to the Verde Valley from Phoenix. At a stop known as First View, train passengers got their initial glimpse of the vast display of red rocks and cliffs that stretched from Sycamore Canyon to the Mogollon Rim. This viewpoint is now an observation stop. Two other lesser-known spots for looking down at Oak Creek Canyon and Sedona also offer bird's-eye views: the summit of Mingus Mountain, and the top of Schnebly Hill.

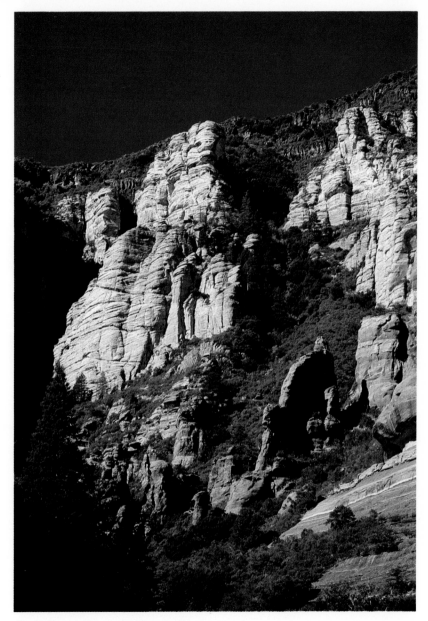

Cascading color on canyon wall

INTRODUCTION

As one looks into the canyon, cliffs and mountainsides reveal the multicolored layers in a natural cutaway, the result of untold centuries of erosion and geologic realignment. The layers were exposed and then worn by eons of sun, wind, and water into spectacular shapes as intriguing as their various names: Courthouse Rock, Steamboat Mountain, Giant's Thumb, Capitol Butte, Coffee Pot Rock, and Merry-Go-Round Mountain. Radiocarbon dating of rocks and fossils in this red rock country indicate that its foundations were laid over one hundred fifty million years ago by a series of vast seas that covered the area. Though estimates vary, it is supposed that eleven or more prehistoric seas covered the region, beginning some three to four hundred million years ago, each depositing its own layer of material and adding to the overall sedimentation of limestone, sandstone, gravel, basalt, and lava. Marine fossils are common in these layers, substantiating this theory.

The massive rock formations, canyons, buttes, promontories, and mesas sculpted by erosion form a panorama that offers both the professional and amateur geologist a textbook example of the power of nature. These are monuments of geologic history, telling mute but timeless stories of birth, growth, death, and dissolution. Towering testaments to the elemental forces that formed the various layers, the red rocks of Oak Creek Canyon and Sedona are still being slowly transformed by spring flood, blazing sun, desert wind, and summer storm. The autumn winds and winter ice and snow continue their work on the stone, persistent hands that trace and retrace convoluted patterns. Seasons in red rock country have always had a profound effect geologically; they also provide the

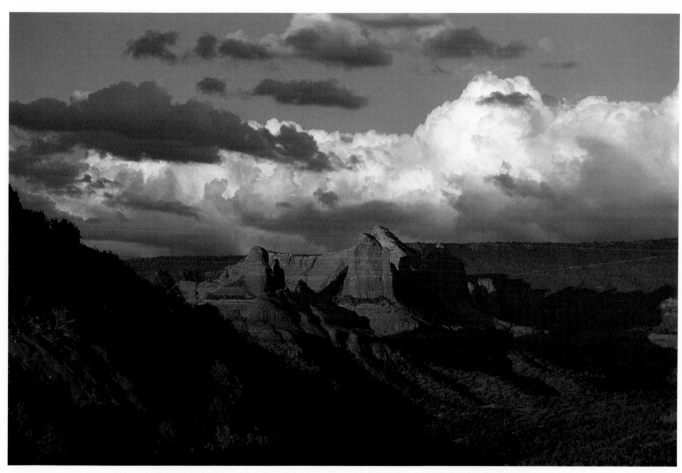

Giant's Thumb and Tea Pot Rock

INTRODUCTION

resident, visitor, and photographer with a truly beautiful environment, one that is reassuringly familiar and yet sufficiently varied for constant inspiration.

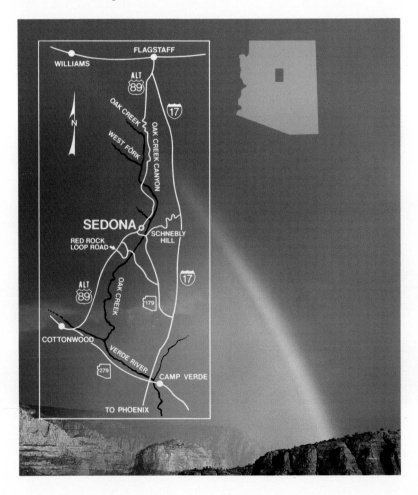

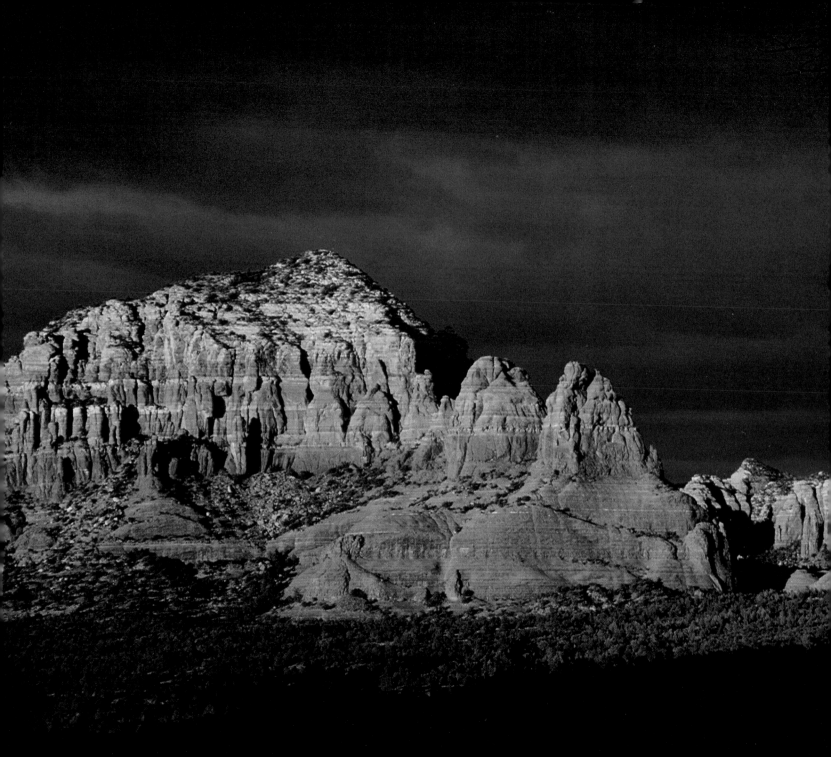

S P R I N G

A time for winter runoffs and thundering, erosive floods— and a time for buds and planting and nature's sweet- scented coquettery.

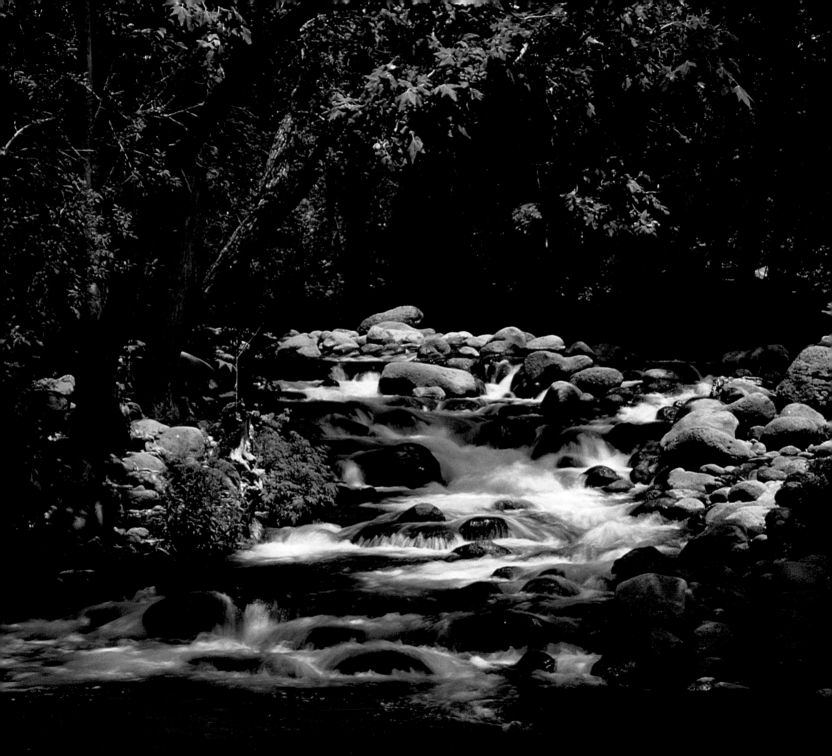

*W*ater characterizes spring in red rock country. As the sun melts the snow pack on the San Francisco Peaks to the north, the ground becomes soaked and the springs that feed Oak Creek gush forth. Occasionally, the creek will overflow its banks; from a sparkling rivulet, it becomes a swollen torrent, sweeping toward the dry arroyos and river beds to the south. Springtime runoff also occurs on both sides of the creek; water cascades down the sides of the steep canyon walls. For those fortunate to catch sight of one, there is scarcely any sight more beautiful than one of these natural waterfalls.

Spring water, clear, sweet, and finger-numbing cold, bubbles from the dark earth. Its pace changes seasonally, yet its effusive optimism sings the promise of new life and rebirth as Oak Creek nourishes the trees and other vegetation that line its banks. Its tranquil murmur mixes with the sweet scent of pine needles, the warm glow of gas lanterns, and the stars' cold, aloof sparkle, reflected on the surface of the moving water.

The gentle, welcoming rush of Oak Creek waters greets the springtime visitor. Gathering momentum and voice, the creek rushes past rock formations and dizzying red cliffs beneath Indian

Racing waters
of Oak Creek

SPRING

Head Mountain. Here, it settles into deep, mysterious pools and gains strength for its final rush southward. Oak Creek tumbles through rapids and waterfalls, splashing in the bright springtime sunlight, past Indian Gardens, Sedona, and the lower part of the valley to its final junction with the Verde River.

While the creek itself, nourished by runoff from the snows to the north, sometimes overflows its banks, actual rainfall in the spring is negligible; April showers are a rarity. Nonetheless, as the last of the cold weather disappears, the trees and shrubs begin to bud and blossom. The native vegetation changes dramatically within a relatively short distance. High-country ponderosa pine and Douglas fir, as well as maple, aspen, and spruce, flourish at the northern end of the canyon; descending toward Sedona, however, low thickets of shrubs begin to appear. Manzanita bushes and chaparral mix with cedar trees and groves of oak and sycamore, which replace the pine and fir trees.

In less than an hour's drive, it is possible to cross several life-zones: southern Arizona sand, cactus, and dry desert heat give way to thick forests of deciduous and evergreen trees and snow-capped mountains that tower 12,000 feet above sea level in the north-central part of the state. Squirrels, skunks, and raccoons are plentiful, and an occasional bobcat or coyote can be spotted. Short hikes back from the roadside will often reveal the tracks and signs of bear, deer, elk, and mountain lion. Over six hundred species of plants and two hundred fifty species of animal life have been catalogued in this stretch of canyon.

Naturalists are not the only individuals to have been drawn to the area, however; thousands of artists flock to Oak Creek Canyon

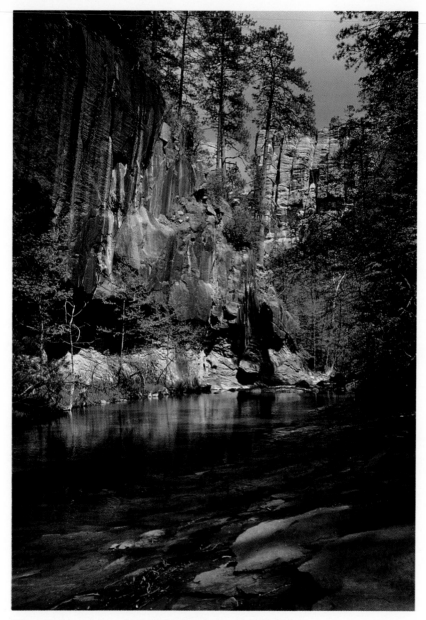

West Fork crossing, bathed in dappled spring light

and Sedona in the spring to paint, sketch, photograph, and other-
wise eulogize their beauty. Balmy spring weather also brings out
the hikers and the fishermen.

The hikers can often be seen at first light, taking to the trails
at Harding Springs and West Fork. Bird watchers, animal lovers,
amateur botanists, or those who simply love to explore, they
breathe deeply of the morning air, keeping a sharp lookout for
chickadees, chipmunks, and Brown Creepers. Agave can be found
in the more arid regions, and narrowleaf — or banana — yucca
blooms beside desert wildflowers in a tapestry of scarlet, purple,
and purest white. Some of the hiking trails were originally created
by early settlers, who needed to cross the rim of the canyon to
reach Flagstaff. These hardy souls, who had left their wagons on
the canyon's rim, ascended the trails with pack animals, hitched
them up, and followed the wagon ruts into town. Once back at the
rim, they unloaded their provisions, unhitched the animals and
loaded them up, and descended to their homes in the canyon. The
more popular trails include the Purtymun, about nine miles north
of Sedona, opposite Junipine; Thompson's Ladder at the mouth of
Munds Canyon near Indian Gardens; and the West Fork Trail,
approximately ten miles north of Sedona.

The vegetation and wildlife are more varied at the West Fork
Trail than anywhere else in the vicinity. This trail picks up on the
shoulder of Highway 89, fords Oak Creek, winds past the brick
chimneys that are all that remain of Mayhew's Lodge, and on
westward along a small stream. Most hikers allow a full day for
this walking and wading jaunt through larkspur, buttercup, and
other beautiful wildflowers. A canopy of cottonwood, box elder,

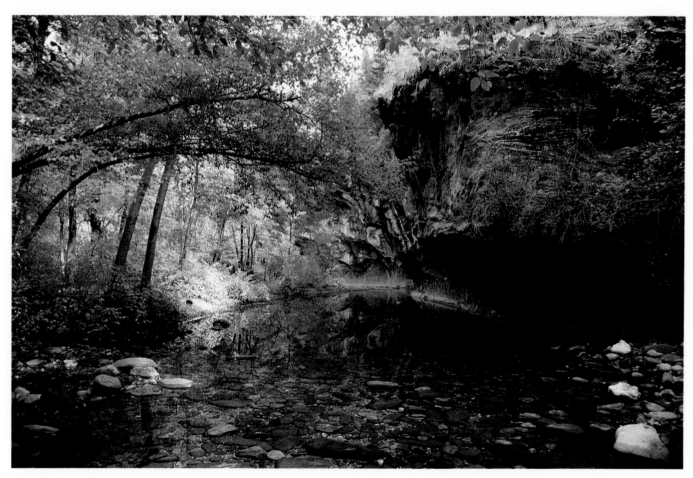

West Fork, Oak Creek Canyon

walnut, pine, and fir adds a soothing sense of serenity and time-lessness, as well as providing a nesting place for canyon wrens, belted kingfishers, red-crested woodpeckers, and a host of other species.

The fishermen, sometimes seen standing motionless in their waders or along the creek's edge, are often anglers in the true sense, wise to the ways of the trout they have long battled and outwitted. They know the places in the rapids where the big German Brown trout come to feed, and they know how to whip a dry fly on a tapered leader to within inches of the place behind the rock where the game fighter rules supreme. They know just which coachman dry fly to use in the morning light, and when and where to drop a grey hackle from the banks of a placid pool in the waning spring evening. Grasshoppers, night crawlers, and the native helgramite, a creature that lives in Oak Creek and somewhat resembles a legless centipede, are all as familiar to these experts as the flashing trout that strikes, seldom but true, at the fishermen's delectable offerings. The state hatchery stocks Oak Creek on a regular basis, but these anglers would rather labor for hours and take nothing from the spring-fed creek than catch their limit of "stockers."

In April and early May, creek waters are still a bit too cold for all but the hardiest swimmers; the deep pools of lower Oak Creek are warmer and more inviting. The desert climate south of Sedona is also very pleasant during this time of the year. Jeep tours along the Red Rock Loop Road are available and allow greater access to the backcountry. Some of these tours go into the wilderness area surrounding Schnebly Hill Road from Sedona to the Mogollon

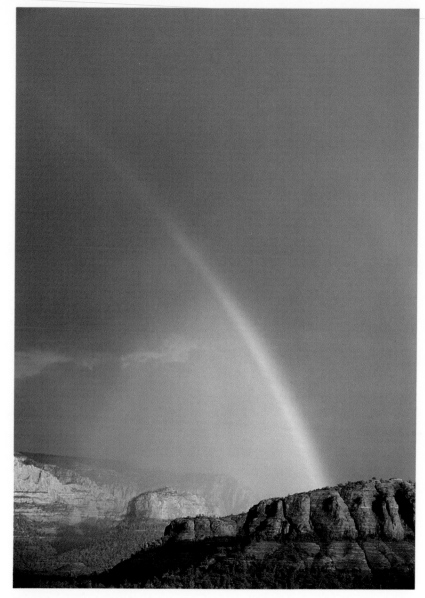

Rainbow over red rocks

Rim. Rock formations are particularly striking in this area, which has been a favorite location site for such Hollywood westerns as *The Cisco Kid* and *Virginia City.*

Oak Creek Canyon is also a great place for doing nothing more than idling in the sun, communing with nature, picnicking, or meditating beneath a tree, listening to the timeless song of spring, a song that begins to fade in late May, as the gentle season's tune assumes an adagio rhythm. The tempo slows as warm, lazy days lengthen, ushering in a new and languid mood. Fresh spring breezes give way to the stillness and rising temperatures of summer.

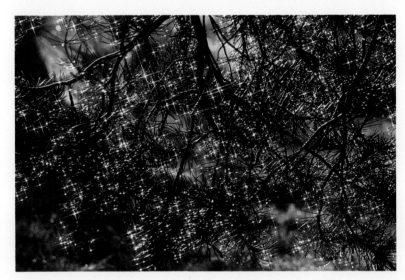

Tree decorated with spring raindrops

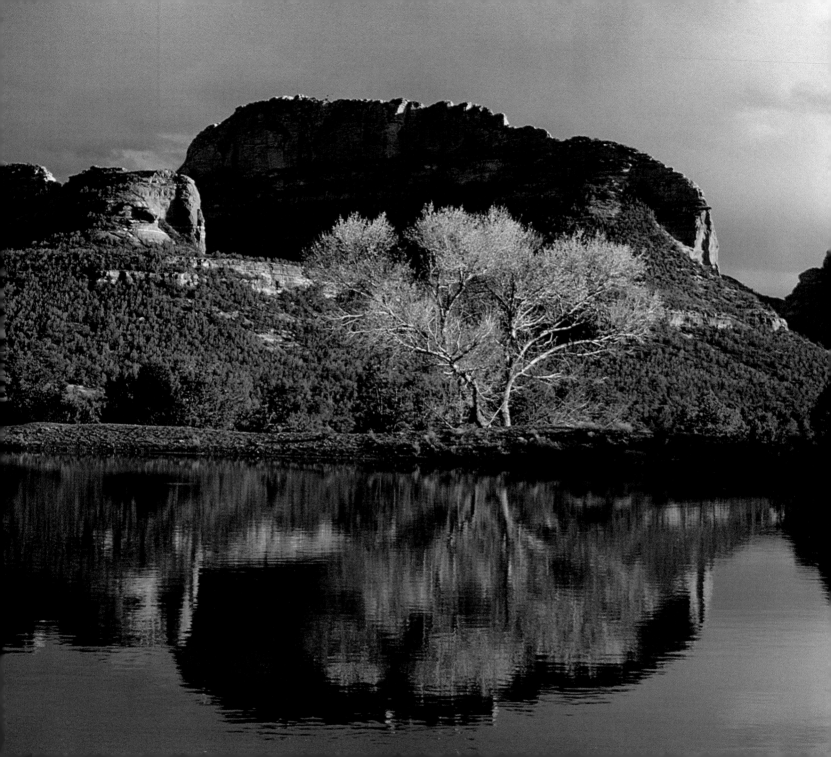

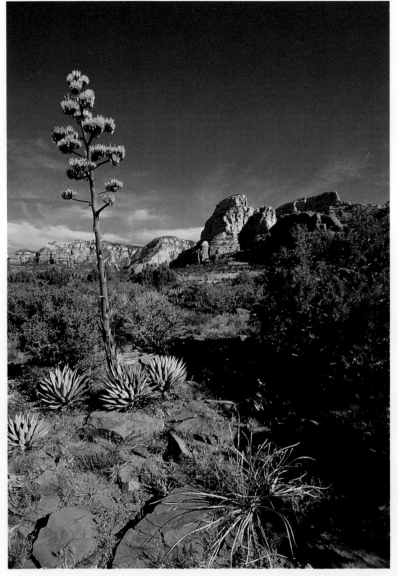

A majestic magae *(century plant) in Canyon del Oro*

*Misty rain and rainbow
over Morgan Stable Canyon,
film site of many
early-day western movies*

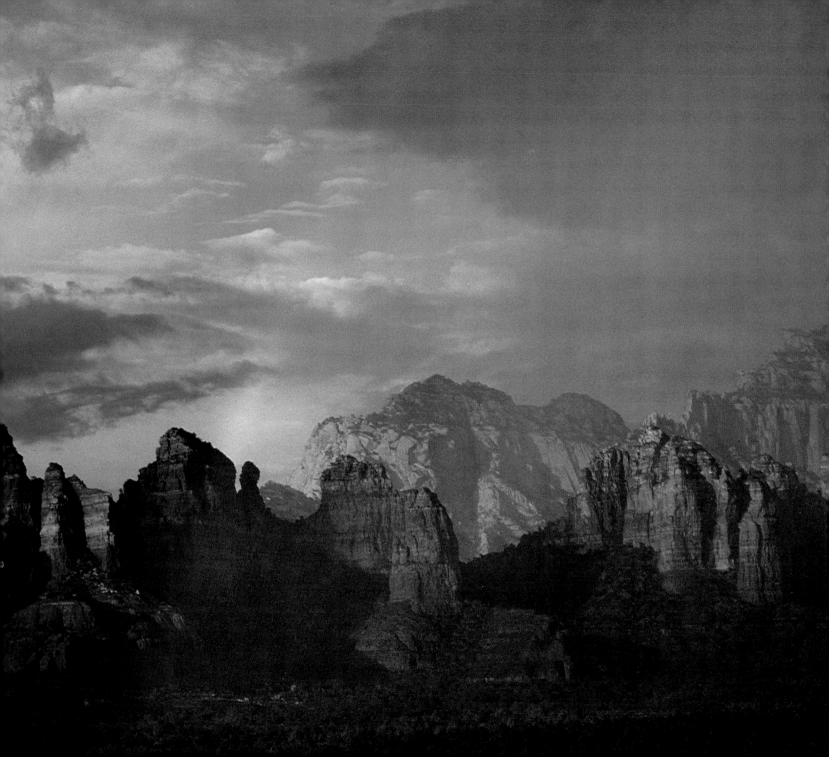

S U M M E R

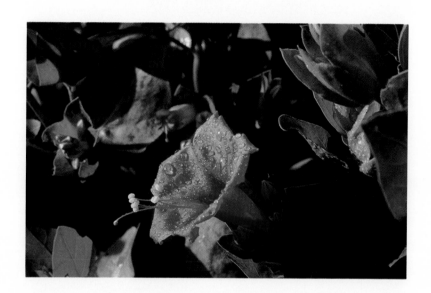

A time for growth and expansion
and nature's heat and passion.
A time for wind-driven sands and
mountain thundershowers that
carve and sculpt red cliffs
beneath a searing desert sun.

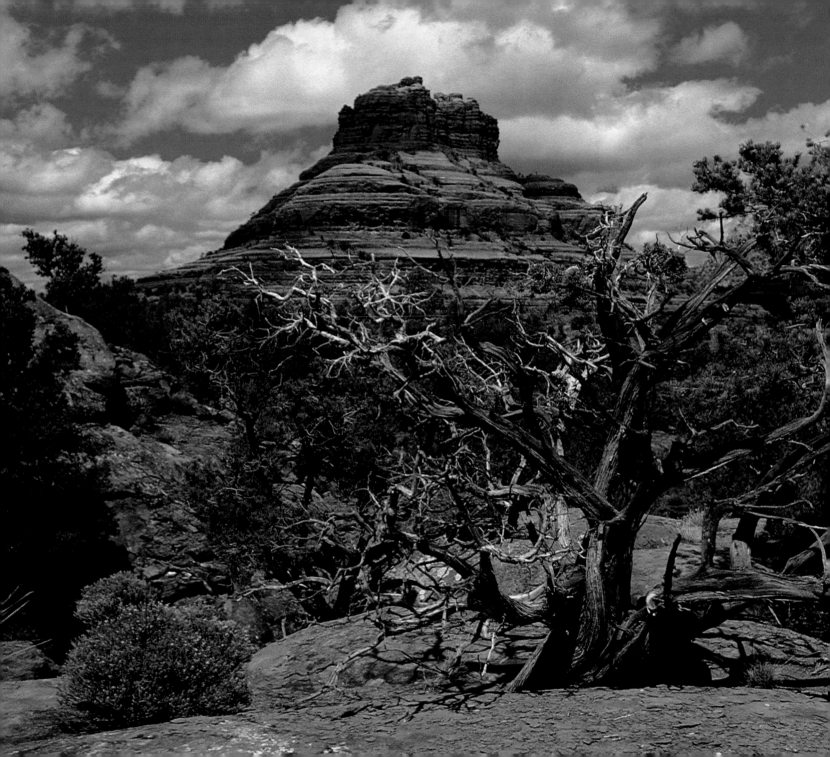

S U M M E R

*V*acations and warm weather, combined with spectacular scenery and accessibility, make summer the "peak season" in Oak Creek Canyon and Sedona. Summer is the time for art shows and music festivals, locally grown fresh fruit and vegetables, and scenery captured forever on endless rolls of film.

It is hot, but nature has her own way of providing a refreshing and invigorating respite: mid-afternoon thundershowers blow in almost every day from the middle of July until the middle of September. Summer is the wettest time of the year in the canyon, due to southerly winds that transport moisture-laden clouds in from the Gulf of Mexico.

Lightning flashes. There is a deep, brief silence and then rolling thunder cracks and echoes from canyon walls to lofty rock formations and back again, a symphony of summer sound. Skies darken, and the wind increases. Rain, when it comes, is spotty at first; then it seems to pour down in funnels, or sheets. After these brief episodes, which usually average less than an hour, there is a sweet scent of pine needles and an aroma of wet sandstone and desert soil. A sense of well-being, of exhilaration, is pervasive.

As the storm subsides, people emerge from shelter to resume

Bell Rock

their activities, which usually include visiting the many points of interest in the area. Among these is Courthouse Rock, also known as Cathedral Rock, located south of Sedona on Red Rock Loop Road. This is probably the most photographed bit of the canyon landscape. A pool near its base mirrors massive red spires that thrust abruptly from the evergreen hillsides in a subtle explosion. Southeast of town, on Highway 179, Bell Rock and the Chapel of the Holy Cross are two lovely attractions, set in a background of serrated red, pink, and buff rock formations. From the town of Sedona, Camelback Rock looms majestically, seemingly only a stone's throw to the east, at the base of Schnebly Hill Road.

Boynton Canyon, located in the Dry Creek wilderness west of Sedona, is totally isolated and breathtakingly beautiful. Long one of the area's most unspoiled regions, Boynton Canyon displays majestic Toroweap, Coconino, and Supai cliff formations, reminiscent of what the area must have looked like thousands of years ago. Northward from Sedona, Giant's Thumb stands out in solitary splendor.

As late afternoon gives way to an early summer evening, shadows change and deepen into peaceful pools near the stark silhouettes of rock formations. Sunset comes early in Oak Creek Canyon, where towering cliffs and mountainsides block the sun's light, and cool, gentle breezes rustle chaparral and cedar trees. The incessant hum of cicadas gradually subsides, and birds begin their evening nesting; the sharp cries of the quail echo along canyon walls. As campfires are lit, the animal population begins preparation for another night of foraging beneath the moon. Twilight descends. Time suddenly seems irrelevant.

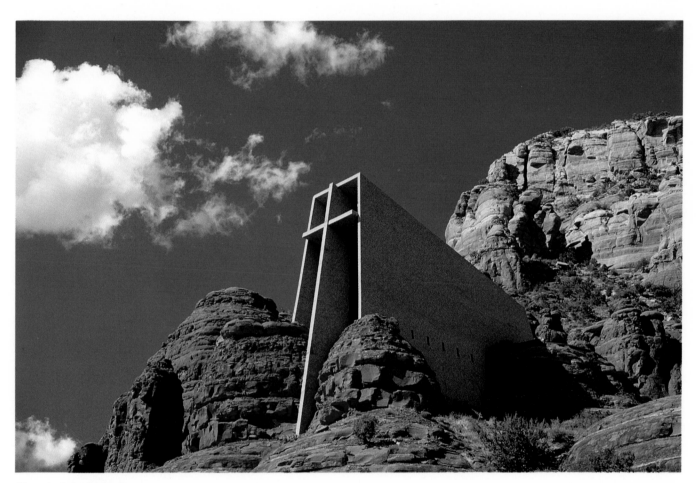

Chapel of the Holy Cross

S U M M E R

South and west of town, the skies are aflame with a desert sunset. The brilliant colors are so intense that it seems for a moment that the whole world must be colored red. Gradually, scarlet fades to a glorious bright pink, and then to a subdued glow of orange and rose. Finally, the evening sky is consumed by ghostly mauve and lingering blue, colors that seem reluctant to give way to the light of the rising desert moon.

Summer begins to wane in early September. The first chill of autumn signals another seasonal change in red rock country. Summer has come and gone — fall is here.

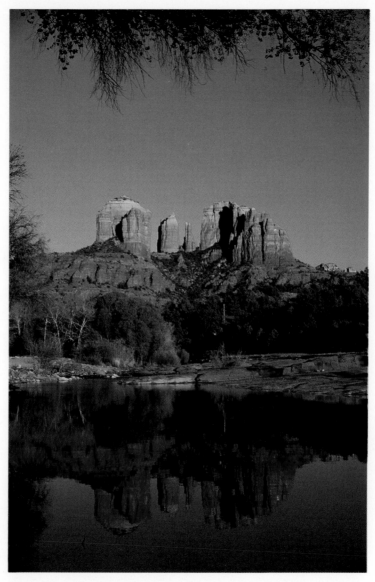

Baldwin's (Red Rock) Crossing

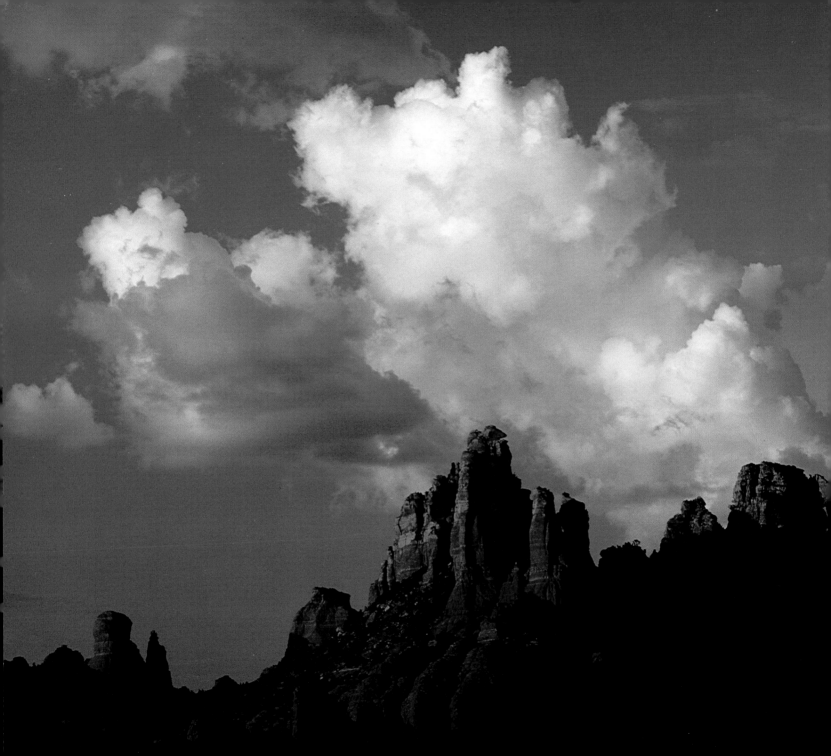

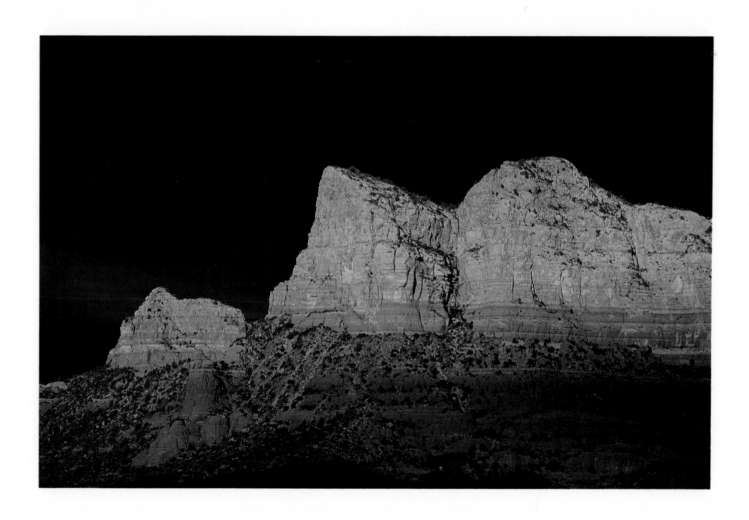

Left: *Eastern canyon cliffs*

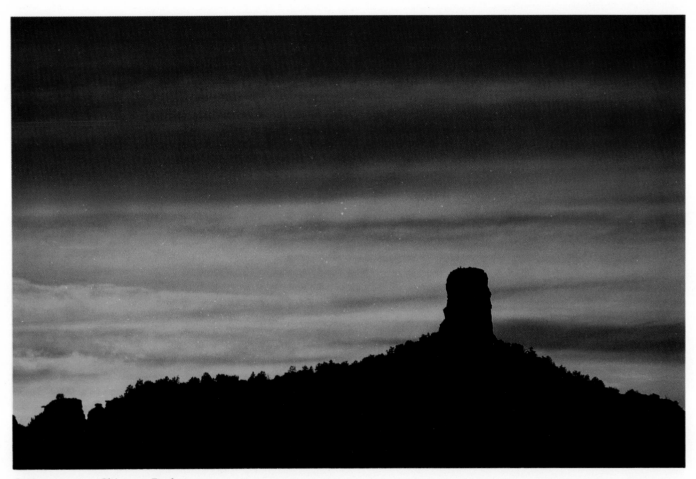

Satin sunset at Chimney Rock

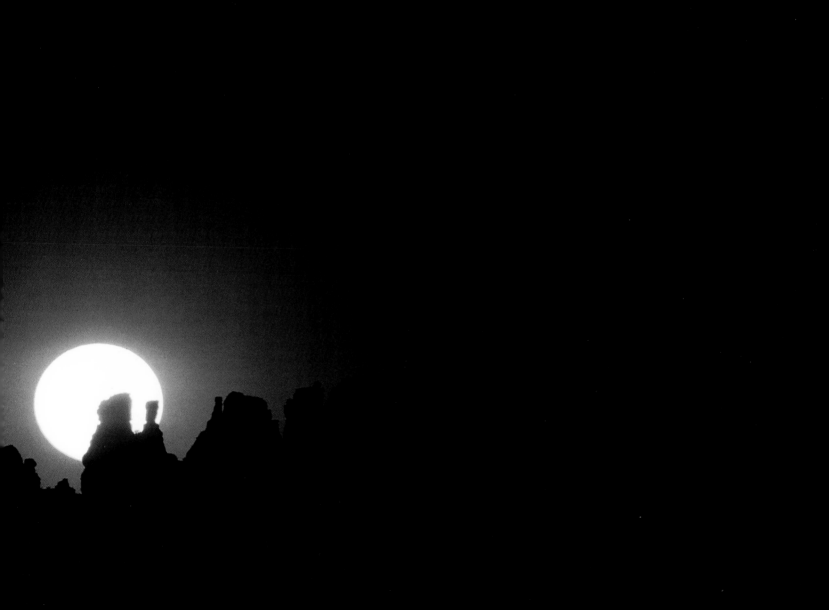

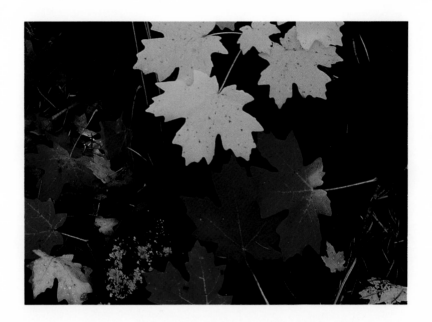

A time for harvest and abundance
and nature's splendor and fertility.
A time of flaming leaves and
cascading autumn colors.

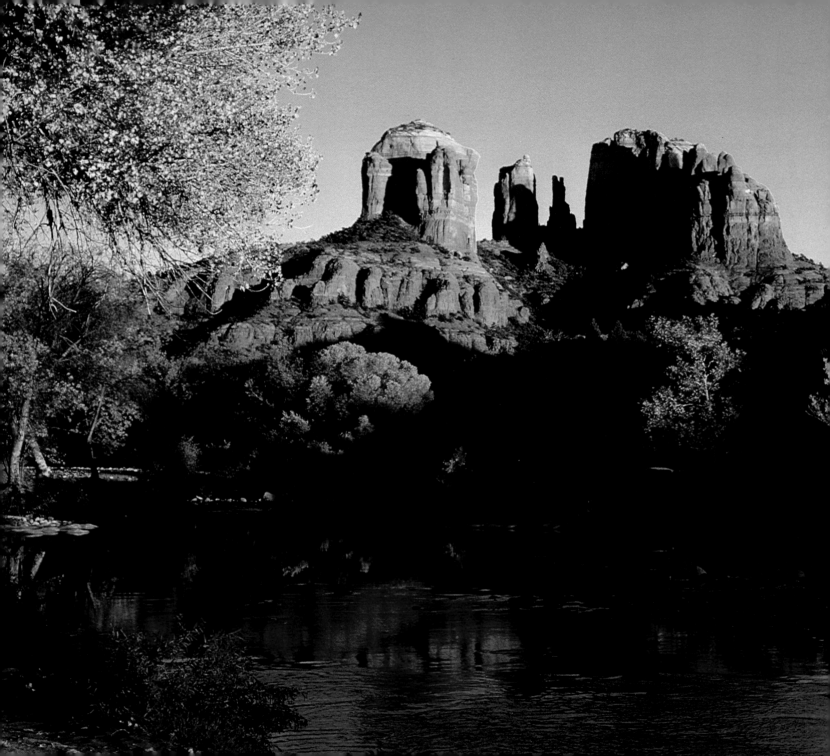

F A L L

*I*t begins with the maples in the uppermost reaches of the twelve-mile gorge. Flaming reds make their appearance, followed by scarlet patches of sumac and rust colors on dying leaves of giant oaks. Orange willows and golden cottonwood and sycamore trees erupt in color around Sedona. The brilliant hues surge along lower Oak Creek and into Verde Valley.

As fall descends into the canyon, cascading southward from the switchbacks like carelessly spilled painter's oils, verdant green gives way to gold, rust, and tangy red. For many, this is the favored time to visit the Oak Creek Canyon-Sedona area. One of the best vantage points to observe the progression of fall in the canyon is at the top of the switchbacks from Observation Point. The canyon's seasonal splendor spreads like a giant patchwork quilt.

Turning leaves are brief pages in an unfolding text. The colors parade steadily before an advancing frost. In late September, or early October, cold weather begins to sweep over the north rim and down into the higher elevations of Oak Creek Canyon, although freezing temperatures seldom arrive until Halloween or the first of November.

Swimmers have abandoned the creek, but this is still a good

*Courthouse (Cathedral) Rock
and Baldwin's Crossing*

F A L L

time of the year for fishermen, who angle for the game fighting German Brown trout. Further south, where Oak Creek unites with the Verde River, the season for channel catfish reaches its peak.

Short, lazy Indian summer days are just warm enough to be comfortable in shirtsleeves or a light sweater, but brisk enough to invigorate. As darkness descends, crisp fall evenings demand heavier clothing. Those who camp under the stars during this time of the year are rewarded with a heady infusion of oxygen and the incredible freshness of awakening to an autumn morning.

The West Fork Trail is an excellent place to be during the fall season, as the magic of autumn sunlight turns oak leaves into golden lanterns. This is one of the few places in Oak Creek Canyon where the four major fall colors are visible at the same time amid stands of cottonwood, box elder, maple, and aspen trees. Beside the nearby creek, sycamore trees flourish, along with fir, willow, sumac, and apple.

Champagne air, lightly chilled, caresses the area and its inhabitants, who are fewer in number than during the summer. Children are back in school and visitors have returned to their homes and jobs. Autumn sunlight reflects from rose-colored cliffs and glinting creek waters. Soft smoke drifts hazily upward from chimneys. Sound carries, far and clear; everything seems very calm and tranquil. The last flowers of summer have long since faded. A hush descends, prefacing the great silence of winter.

Red maple leaves against the cliff face

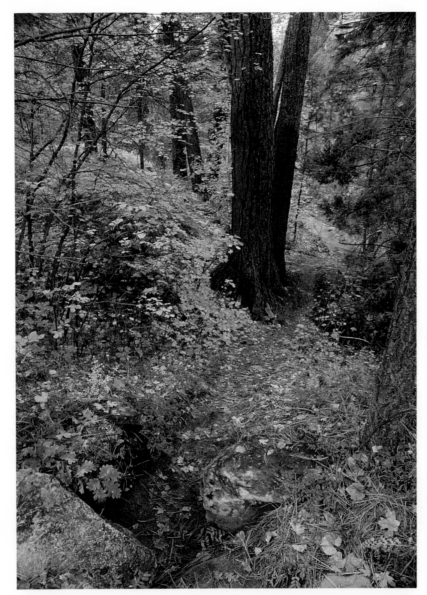

West Fork Trail

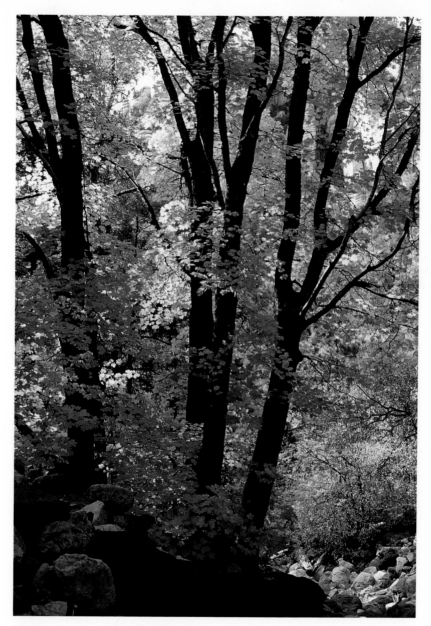

Trail to the site of Mayhew's Lodge

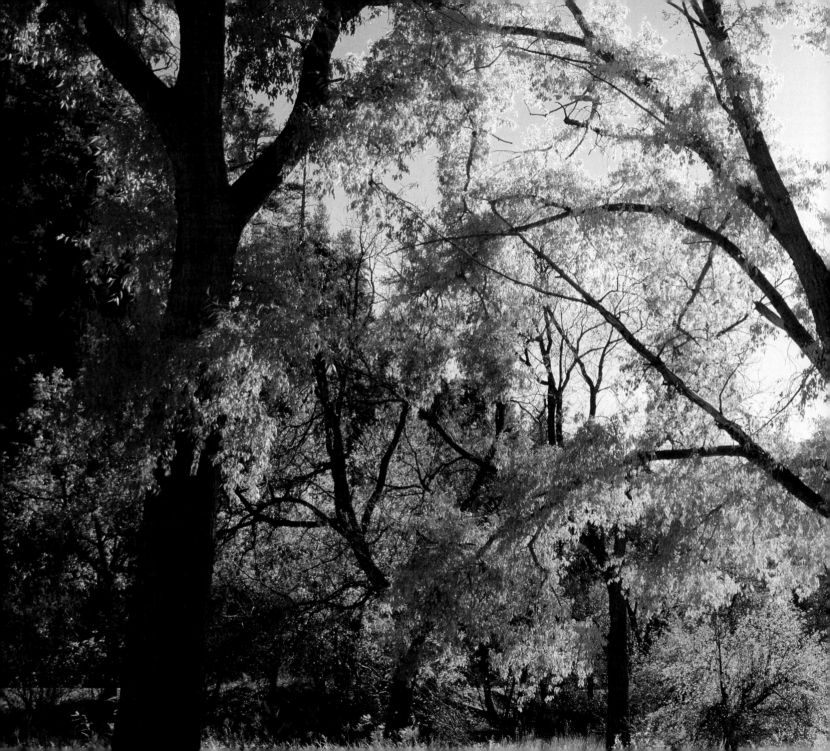

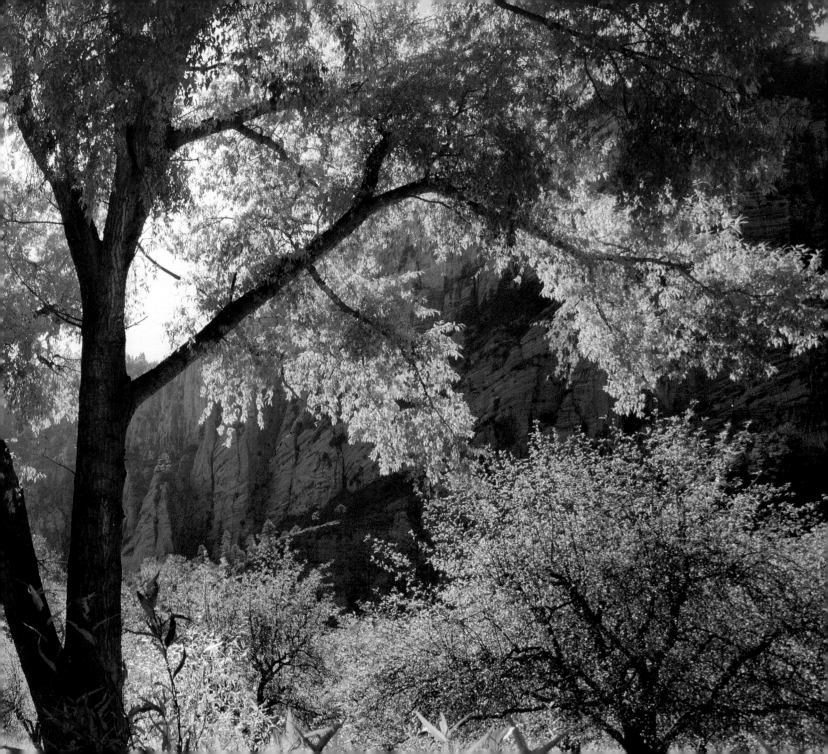

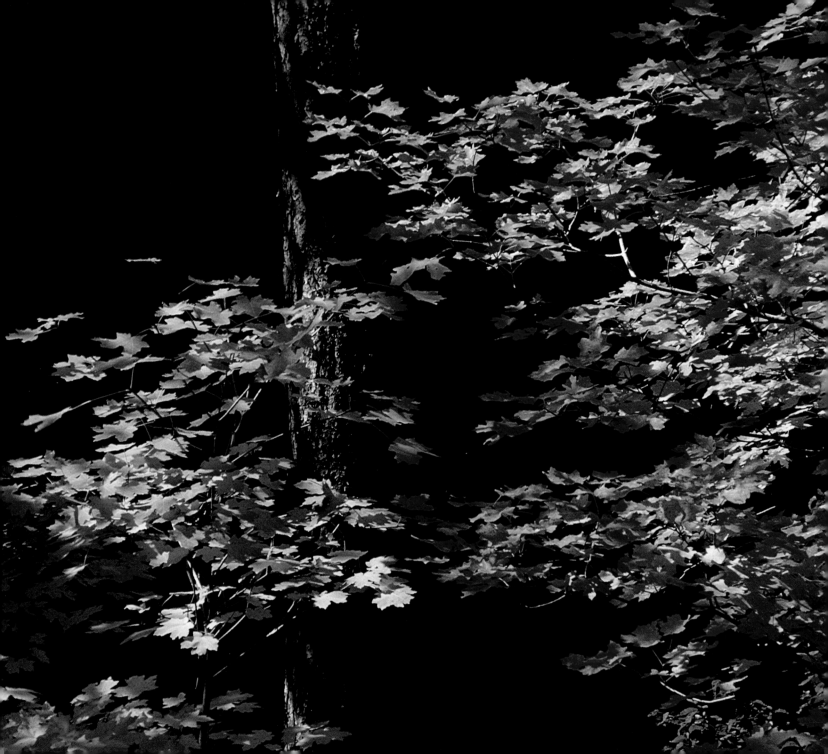

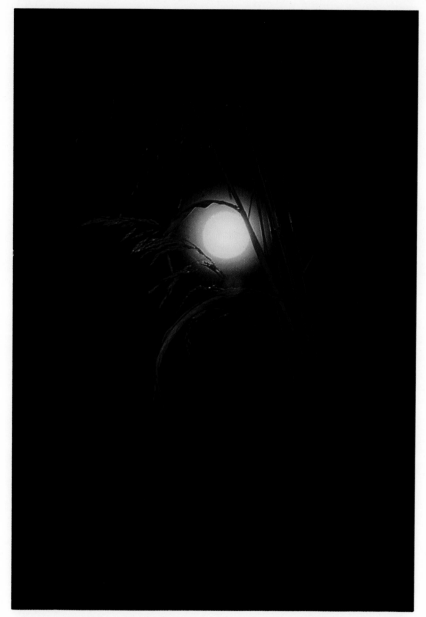

Moon of the changing seasons

W I N T E R

*A time for rest and meditation
and nature's reflection and repose.
A time for the regathering of
awesome energies and power which
slumber beneath a frozen surface,
locked within the white-mantled
peace and beauty of ice and snow.*

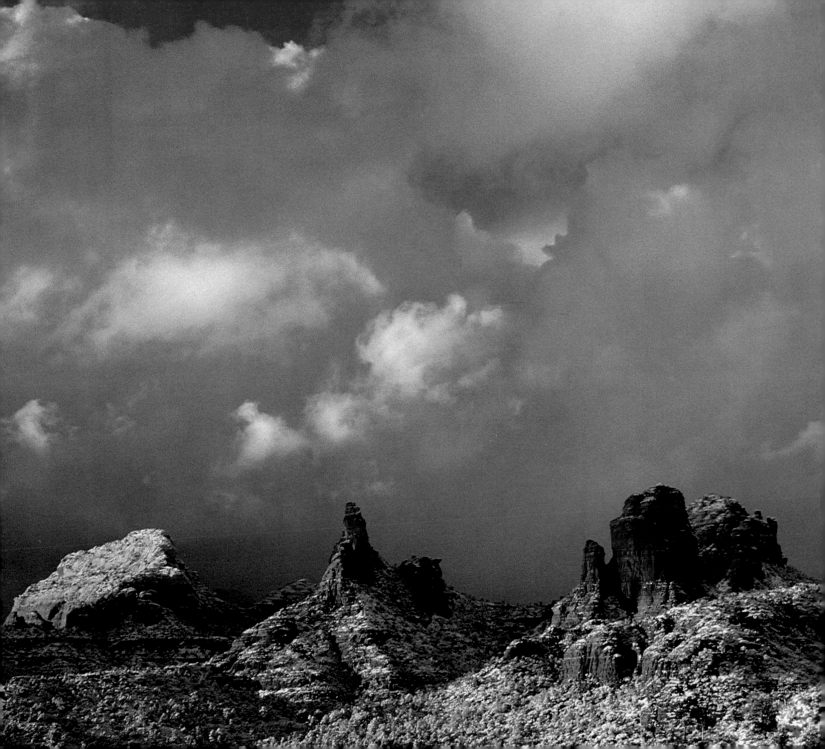

W I N T E R

*S*now drifts over red rock country like a soft comforter. Silence deepens, broken occasionally by the sound of tire chains. Those who have homes in the canyon often must travel northward, to Flagstaff, to work; others come up for the weekend, or longer, from Phoenix in the south.

During the winter, places like the Sedona Arts Center offer seminars and classes for local painters, sculptors, actors, and musicians. The splendor of winter offers many creative people an inspirational pageantry of artistic excitement and stimulation. Combinations of sun, snow, and low-hanging clouds present an endless and dazzling variety of images.

The forces of creation are as constant and never-ending as the artistry they inspire. Desert monoliths, shaped by eons of erosion, still undergo great cyclical changes; yet they somehow appear ever the same in our brief vision.

Cedar, pine, and piñon boughs bear the snow's weight with the accumulated patience of centuries. At their bases, rabbit tracks scrawl hasty messages. Bitter cold drives other life forms into the desert or deep into canyon crevices and caves. Rattlesnakes tangle companionably, a sleeping mass, hibernating for the winter. Fat

The Sentinel Rocks
at Soldier's Pass

W I N T E R

black bears and bushy-tailed squirrels sleep peacefully, and most of the birds have long since departed for warmer climates.

Vast expanses of ice and snow lie draped against the throats and shoulders of red buttes like white fox or ermine stoles. The contrasting colors, capped by a cloud-dotted sky of deepest blue, are softly lit by a pale winter sun that reluctantly appears and disappears, making evermore brief visits as the winter equinox approaches.

Winter. The entire spectacle of red rock country is suddenly arrested; action stops, and the eye is compelled to take in more. Courthouse Rock looms larger. Baldwin's Crossing seems more serene. Clouds hang protectively over Steamboat Mountain, Submarine Rock, and Mount Wilson at sunset. There is a rosy glow on the eastern cliffs, and Teapot Rock is shrouded in the misty film of the season. Gothic monuments in stone soar high above evergreen foundations, their red shades bleeding through white snow. Swirling clouds are illuminated by the last glow of the winter sun.

Winter is a contemplative time, as silence deepens into utter stillness against the last dusk of a wintery sunset, and early twilight evenings darken into the void of night. It is a time for the regathering of nature's energy and power, which slumber beneath the frozen surface, locked within the white-mantled peace of ice and snow. Spring will return, awakening red rock country once again.

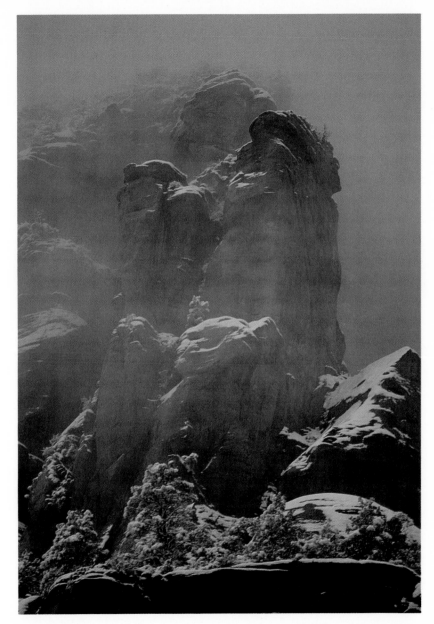

Winter mist

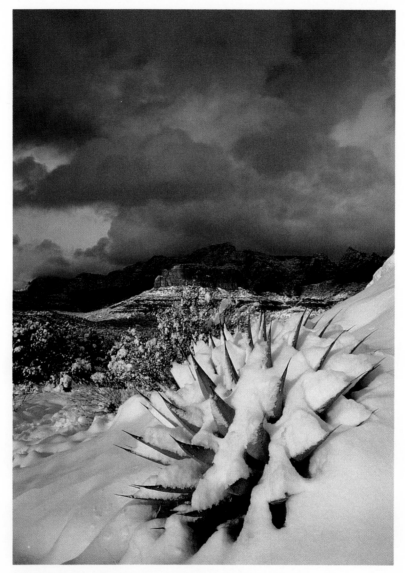

High desert winter

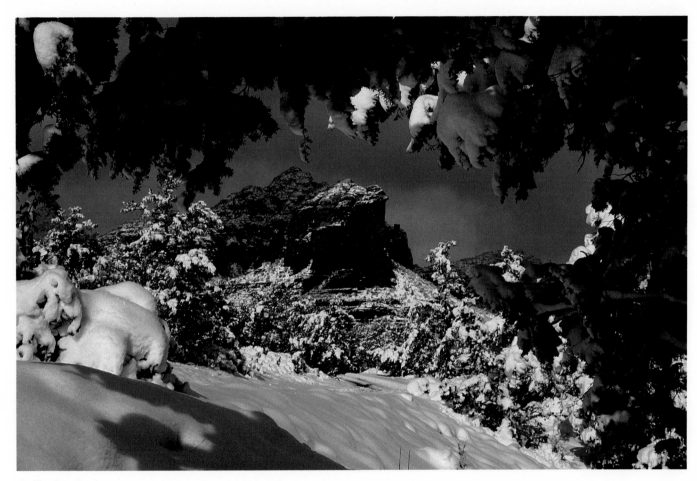

Coffee Pot Rock

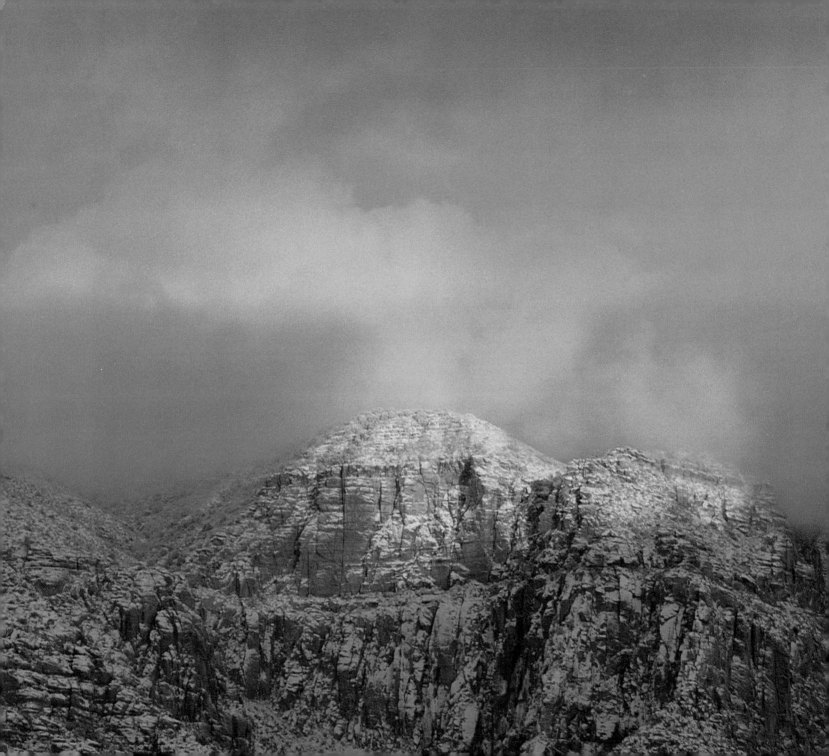

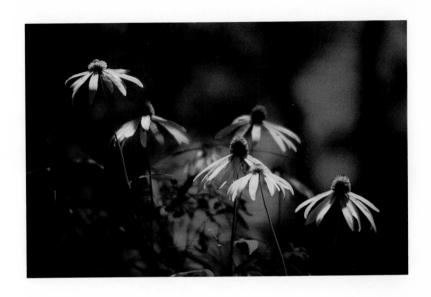

*S*pring *will return,*
awakening the red rock country
once again

A rosy glow on the eastern cliffs

LARRY RUSSELL has had a long, honor-filled writing career. Trained at California's San Francisco State University in radio-television communications and creative writing, he was nominated as one of San Francisco's most outstanding one hundred young men by *Time* magazine and the city's chamber of commerce. His work in documentary films garnered him the Ohio State Award and a nomination for a Peabody Award. Russell has been affiliated with the communication communities of New York City, San Francisco, and Los Angeles, most recently as assistant managing editor for a series on the Disney Channel. Throughout his travels, however, he maintains close and frequent contact with his boyhood home of Sedona, Arizona.

DICK CANBY, currently photo editor of a new magazine entitled *Call of the Canyon,* has lived in the Sedona area since 1961. His work has been displayed in Hawaii, Colorado, Wyoming, New York, Texas, and Arizona and is included in many private collections worldwide. A native of the West, Canby has an understanding of the intricate and fascinating interrelationships between animals, plants, and their environments gleaned from his background in the fields of geology, geography, biology, and ecology. With his self-taught techniques in the use of light, texture, form, and pattern, Canby beautifully captures his respect for all of the natural world.